# Poetry &Paint

## Memory

### Edited by Carmina Masoliver

© The copyright to all work is retained by individual authors and artists.
ISBN: 978-1-326-25154-3

© The copyright for the font 'Dickerson Flat' is retained by Matthew Dickerson, please contact him at matt@matthewdickerson.co.uk for use.

# Introduction

The topic of memory is interesting to record within an anthology. As someone who is obsessed with recording life and has an unnecessary attachment to objects, to record these words and images within such an object allows for a time capsule. Yet, within such a collection of work, the coming together of these artists is by chance. Some may know one another, and others complete strangers. They exist in a memory now, within the memory of the reader, and within the memory of shelves such as the Poetry Library – a moment in time that is captured in book form.

The poems themselves reach into the past, from the historic representing the pathway for a more progressive future in Dean Atta and Ben Connors' work, to a personal history extended through familial roots by Sophie Chei. This issue we also have included poems inspired by outside artwork, written through ekphrasis, therefore without visual accompaniment here. This includes work by Jan See King, and Charle Bane Jr's association between artist Michelangelo and his fame, as if an artwork himself, frozen in time like a sculpture.

Works such as those by Anthokosmos and the collaboration between Jackie Biggs and Eloise Govier imply the blurring and fading

3

of memories through time through both the words and the visual expressions. They show how we replay memories like films in our heads, yet we cannot grasp them physically. Then again, the collaboration between Keir Yansen and Louise Sanders shows our attempts to capture the past through photographs; attempts that are arguably doomed to fail.

As I write this, beside me are stacks of books I preserve close to my heart, kept for future children, for inevitable unaccomplished second readings, for pages that make up my identity somehow. I have two piles that I intend to reconnect with, finding quotations to copy into another book I will rarely read over. These tasks still seem important to me. Somehow, hanging on to these material objects, and the fight to keep the printed pages of books such as this, it seems an integral part of life. Otherwise, we may have to think about what memories mean, our past slipping away by the second. With that rather dire conclusion in mind, what has been a pleasure to see within the contents of these works is the uplifting nature of the reflections on these pages.

Carmina Masoliver, Editor

# SOPHIE CHEI

## How I came to be British

> *India, partition,*
> *2 mixed race bodies,*
> *1 female, 1 male*
> *Boarding a ship*
> *with no belongings.*

I imagine a frenzy of activity
Rushing, the hive melting
The honey gushing
Feet sticking
When they should be running
Leaving the sweet fruits of labour
Behind

Droves of aliens scattering
Displaced, you hold one suitcase
And a passport
To a home you've never seen
Yet somehow you belong to
A one way ticket away from bloodshed
On your doorstep

Your blood tainted with silks
From interweaving tapestries
This soft, misplaced loyalty
Led you to a country
You were told was Great, United
Skin mahogany
Too light for your old country

Carrying darkness to this foreign kingdom
Filling days with melanin
You are not good enough:
For where you came from

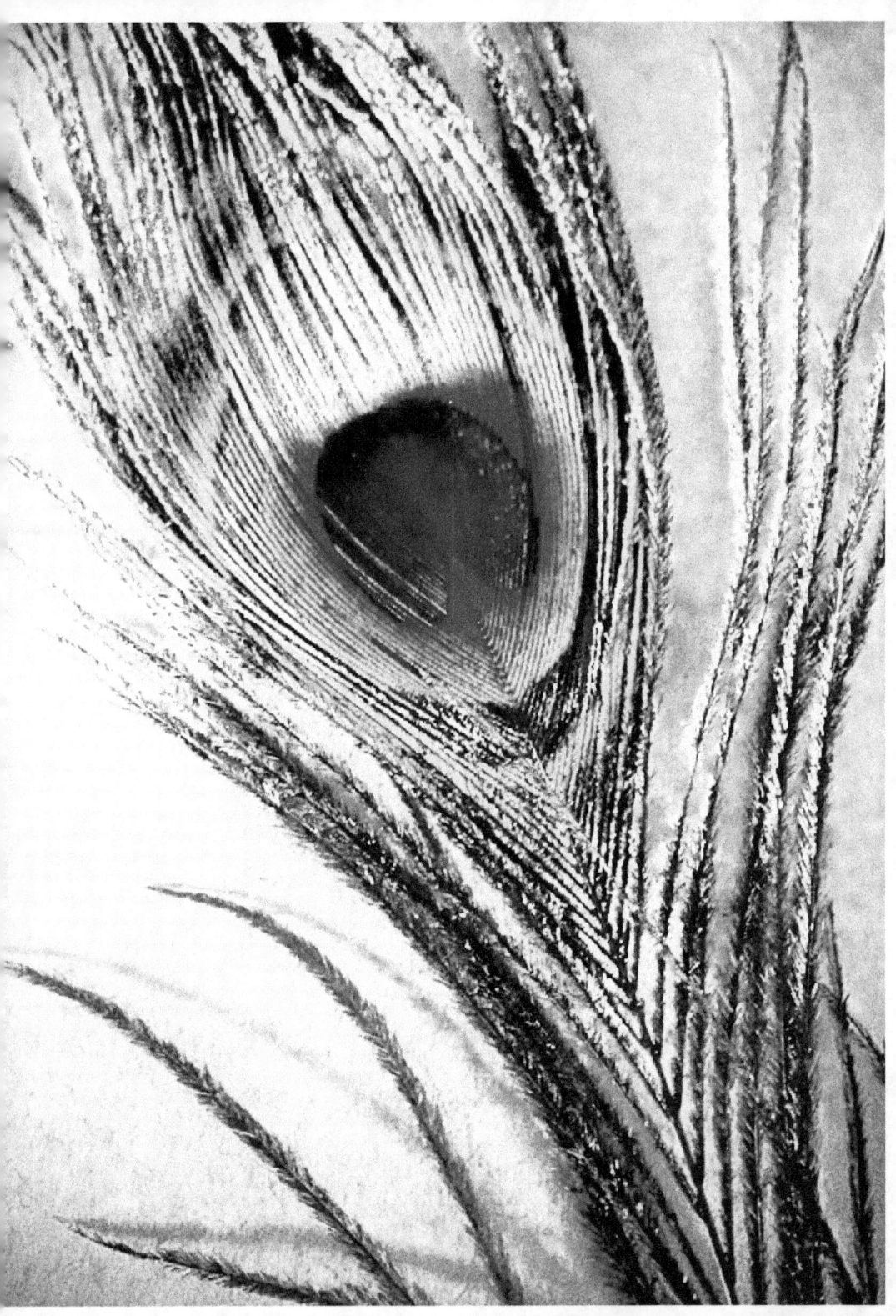

Or for where you've arrived
The map in your veins crosses continents
Flesh with no border control

You own nothing you can hold
But rich in history you don't know
You stand: one orphan and one bastard son
With a past of death, migration and tea
In this new land you begin again
A womb full of one growing embryo
A woman and the future mother to me

# JAN SEE KING

## Tassysage Bread

Do NATO toys taint snowdrops
so 90 burr-sloped tip sage grow for

bread? Pursue anathema sage
arena   brush—ethos places

tonight. Ravines of bitterbrush are
to bream  eveunderstood.

The Colorado, Columbia
Rivers run mahogany,

pinyon juniper green into
biological soil crust.

These blooms of gland leaves, flights of jay,
raven, warbler, coyote could

Edenate "seas" of the tassy sage seedexude.
Silver, bird-foot, fringe-patch sage approve.

## Arienne Français

Skies fold into them her spires.
She writes them in principles of people
working their prayers with hers into a cathedral.

She reads ImLam and ImLoc crystal, architectural
and elemental. Like muscle, her print lifts palms
through clouds, builds first the spires. You are there

in her silence, your body composed centuries fair
ago until time ripened your presence baroque
on plains of the morrow, untangled, free,

her stone your hair. Boned fortress specie,
by wind she wrote haloed by incense for angels
to make sense for you. Work for the body. Posture

your eyes in search of David writing Daniel's figure
because someone's tongue stressed  cartilage
in present safety. Run, Daniel, inhabit the storms

that wash the monks' songs altering the sour warm.
Write, pen from the virgin palm of Arienne's
resume. Write of you written to portune.

## Nudes Ascending the Cliffs

　　Dusk spooling clouds turned two zeppelins
above sea and palisade, their surveillance

　　hazed. Processions of white horse mist
galloped shelves and inclines, horse tail

　　strata whisking. Motion of fence thread
whipping in wind. Riders jostled

　　off mounts thundered the steeps with thin
legs, multiples of nudes ascending

　　to learn from slopes of their disappearance.
A yellow spur into the ribs of fog

　　drove sweat of the under green blue
thrust. With steeple intent evening galloped.

　　Eyes of vapor dirigible blinked,
read the rainbow's prodding effect then

　　withdrew. On white cliffs the phantoms
combed
　white manes of fog with white　eyelashes.

## Note on the texts:

'Arienne Francais' is ekphrastic in nature, and 'Tassysage Bread' was written for the Eden of the past and present of the rangeland, to rescue it, in part, from slipping only into memory from the imagination of retold stories. Marcel Duchamp's 'Nude Descending a Staircase' inspired 'Nude Descending the Cliffs'.

# DEAN ATTA & BEN CONNORS

## Mandela in the Classroom

Mandela said, *Education*
*Is the most powerful weapon*
*You can use to change the world*

I ask my students to tell me
What they know of Mandela
Each raised hand an answer

*He was president of South Africa*
*He helped to end Apartheid*
*He spent 27 years in prison*

Fragments of fame hang in the air
Like a mobile above a baby's cot
Playing a lullaby of *Free Nelson Mandela*

What songs were you sung as a child?
Stories were you told of your ancestors?
What did your bloodline require of you?

What did your teachers instil you?
Did your friendships inspire in you?
What did your politics demand of you?

What did your marriages make of you?
And your children's futures beg of you?
When did you learn how to be great?

In the face of such injustice and inequality
Was it your comrades and imprisonment?
Was it freedom and becoming President?

Can greatness be sung or written down?
Is it in a classroom or conversation?
Is it in forgiveness or reconciliation?

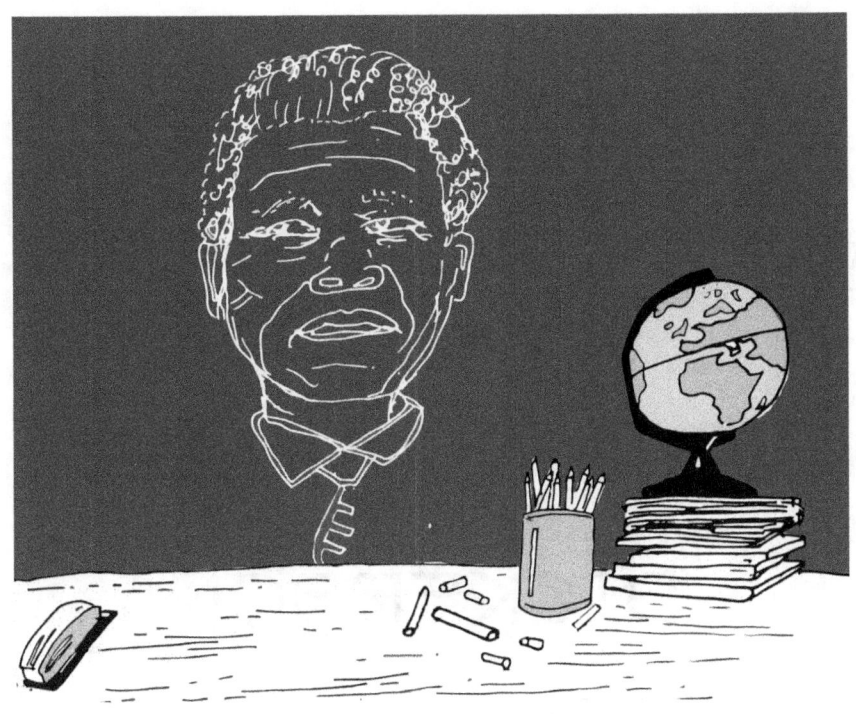

If ever there was a life well lived it was yours
If ever there was a man dedicated to a cause
If ever there was anyone we might agree on

It was Mandela

Yesterday is his
Today is ours
Tomorrow is for the taking

I want my students to wake up and stand up
And grab what they need from his memory
Take what they require for their own journey

To greatness.

# ETHAN TAYLOR & MATTHEW DICKERSON

## Black Bones

Tom's young river whiskey
pulls the village, so neat,
so new to the children,
not like Tom to waste words
or forget them outdoors,
slapping at the thin walls
loud, with his other hands,
trading and burying
names and shoes and black bones
in dirt outside the home.
His drink tempts the lips he
kept warm over Winter
and Tom partners the tastes
with the choicest weeds found
across his sleep, for him
to make something of this,
to do something with this,
to build something from this,
to foster these clefts, played
in case he doesn't show.

## He Stands So

He stands so
Short amongst
The world,

They said he'd
Grow into
His eyes

But still he's
Never seen
Enough.

## Two Princes

We built fires from tissue to burn
the wait and see, the responsibility
of every Western fiction in reverse
broke upon our ears as nothing,

cutting teeth as princes on wax seats
that melt in our tussled straw,
a fortnight passed under earth
and we surfaced below a foreign moon.

Lyrics and lines score each falling grain
and now we try to negotiate the beaches,
but inside this glass the heat is a lance
and, as two princes, we stand for the shade.

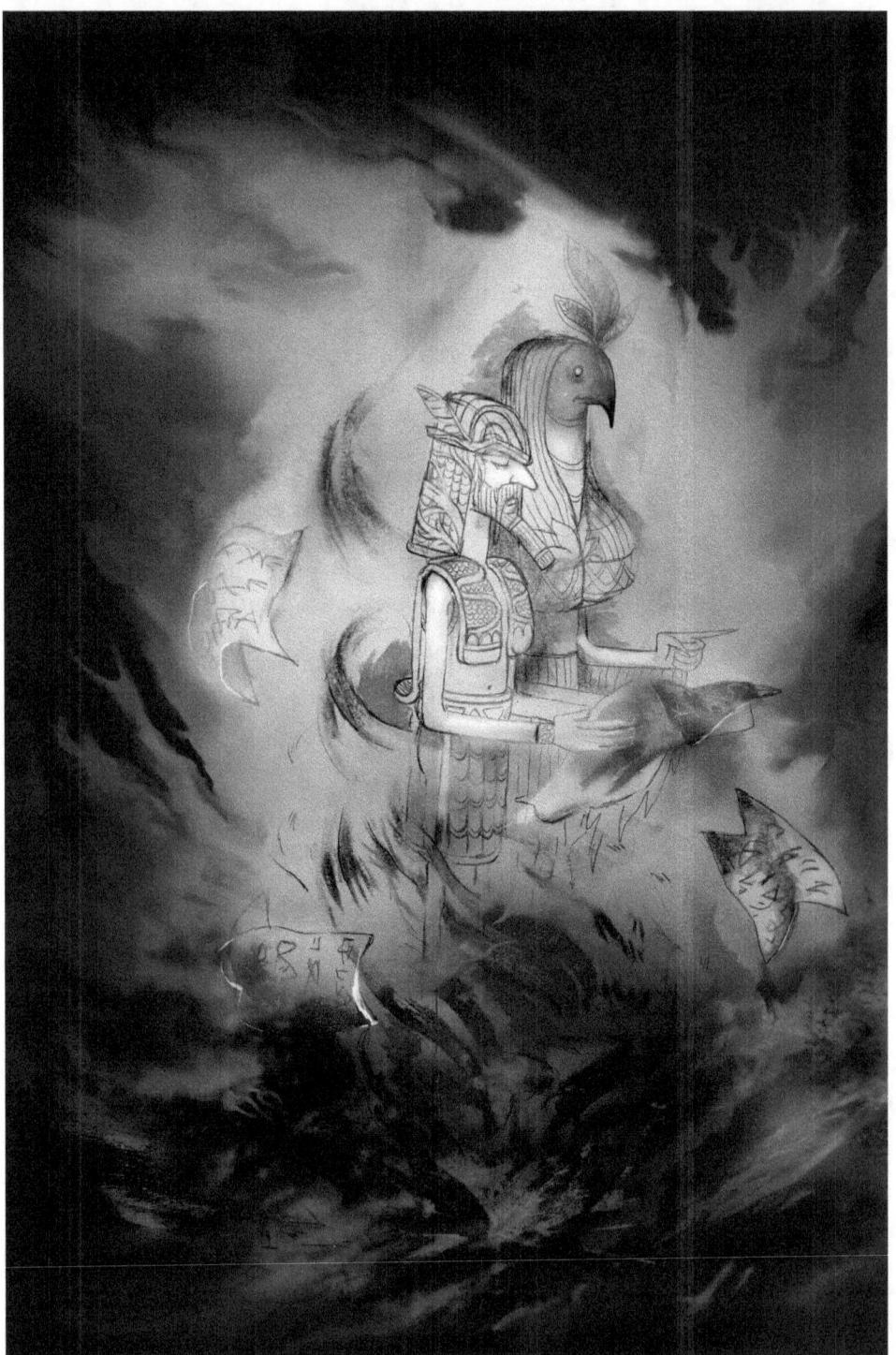

## Soil

Soil fingers the simple flesh
That trickled across our bones,
Each soft prayer caught in the thick dirt
Where the slowest month can't be groomed.

Bring rusty needles in a drink
Sipped in the foothills of language
That wrapped our ears in wool and wire
For the summer years spent abroad,

And I will show you tip culture,
An old song behind the counter,
And four more ways to hold the lid
When the soil fingers your flesh.

## Everything We Have

Windows where we live,
royal in taste,
tonight

play me on the road,
tarmac tonight's
cold tusk

with our last song,
open kisses
with the

next form of sex we
practice apart,
the room

is pulled around you
like everything
we have

and tonight we sleep
so much closer,
at last.

# JACKIE BIGGS & ELOISE GOVIER

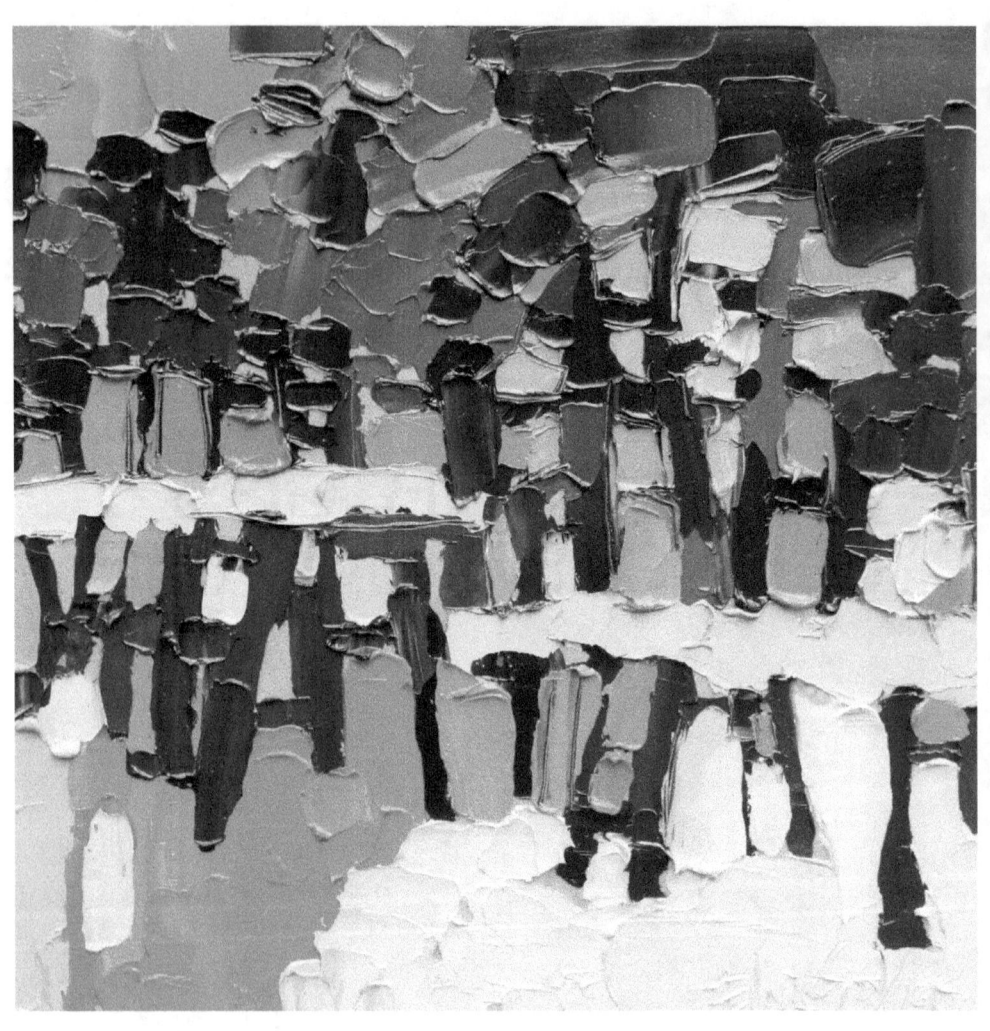

## Colour of memory

We sit by the lake in the midnight woods,
a bottle of red between us;
and while we drain the dregs
we try to recall

where our memories were left.
A green moon and its ruptured echo slips
with our recollections into pools
and our remembrances suck us down.

The night-forest is somehow reflected in
yellow,
and purple leaves shine over the lake,
where these opposites
will not draw each other.

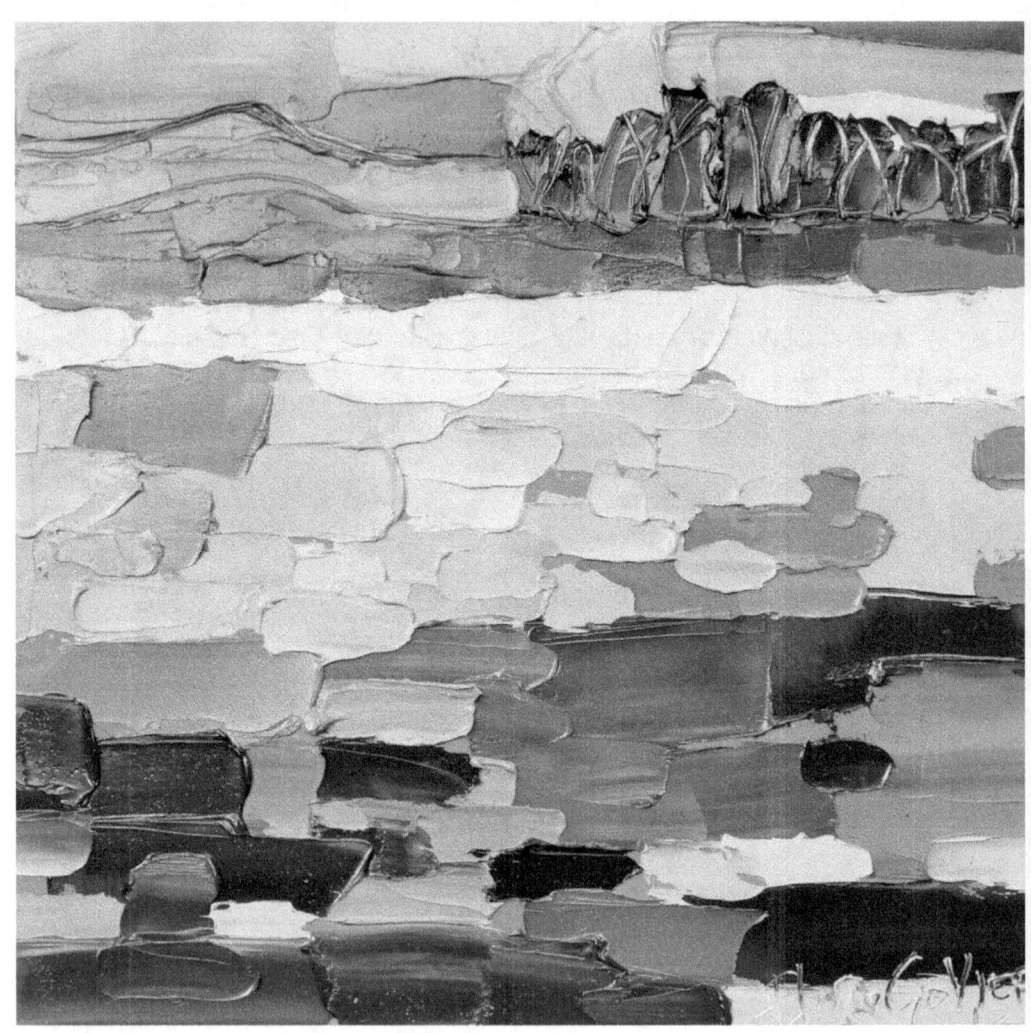

## Under the surface

Sharp accents stab at memory, as
phantoms slip through a dream.

Scarlet flashes signal sparks of recall, but
if you try to see they twist away,

all you feel is the blackness of fathoms
and the silence of hidden water as you

travel to the forest in the farthest corner
of your nightmare.

You understand only shadows
in the layers beneath the surface.

# CHARLES BANE JR

Michelangelo
cannot catch his breath.
He says nothing
to his companions.

How do you say,
the dust is numberless lights
that fall in fiery trails
on clothes and hair
and moving hands?

How do you say,
I labor here as the Maker made,
in shrift, a whole that echoes
in my every strike,
and bathes my face in rain?

My hands move in dreams
I cannot show.
Go home, take wine.
My neck lies on David's
like a brother.

# KEIR YANSEN & LOUISE SAUNDERS

## The Road to Armagh

I keep a black square wooden frame
Proudly resting on a ledge
High above a scented candle flame
It holds smiles that last forever
Faces and all the names.

My raven hair is slowly greying
As I age you never change.

Such a vivid memory
Escapism, you set me free
From an island surrounded by water
To my Ireland I miss infinitely
My family.

All the craic
All of you
A picture framed will never do
But I'll place it by my heart
Until I'm right there next to you.

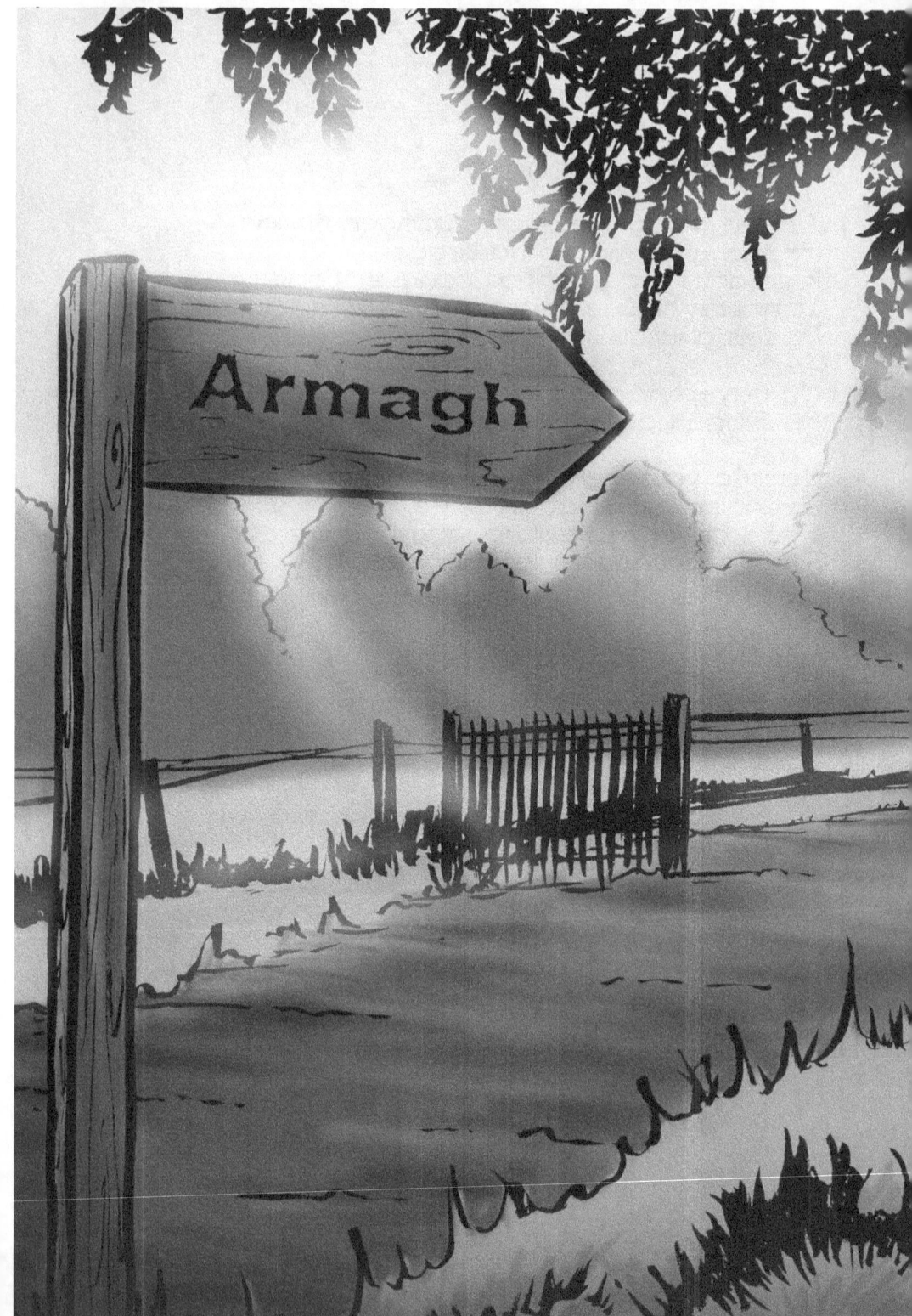

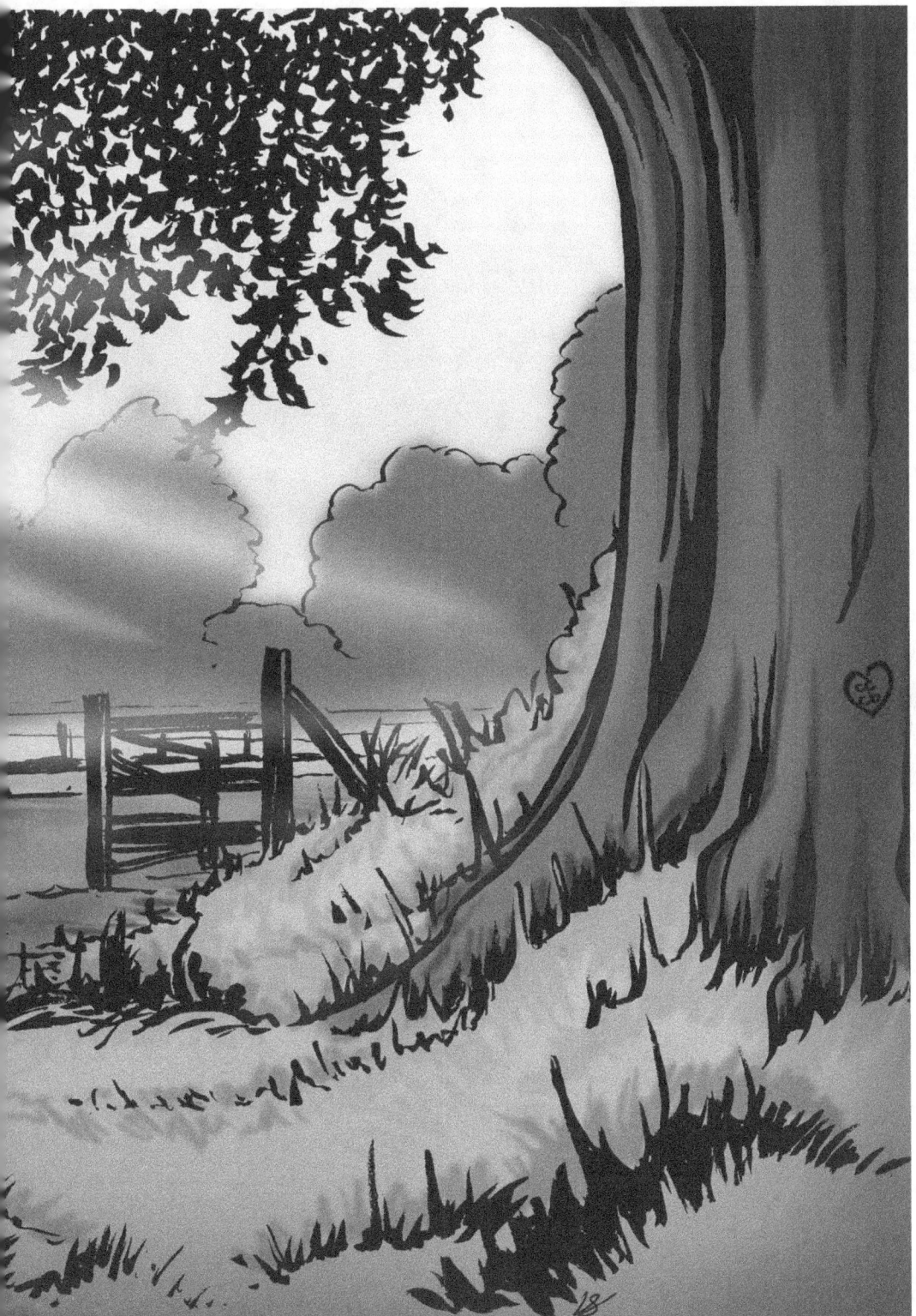

# ANTHOKOSMOS

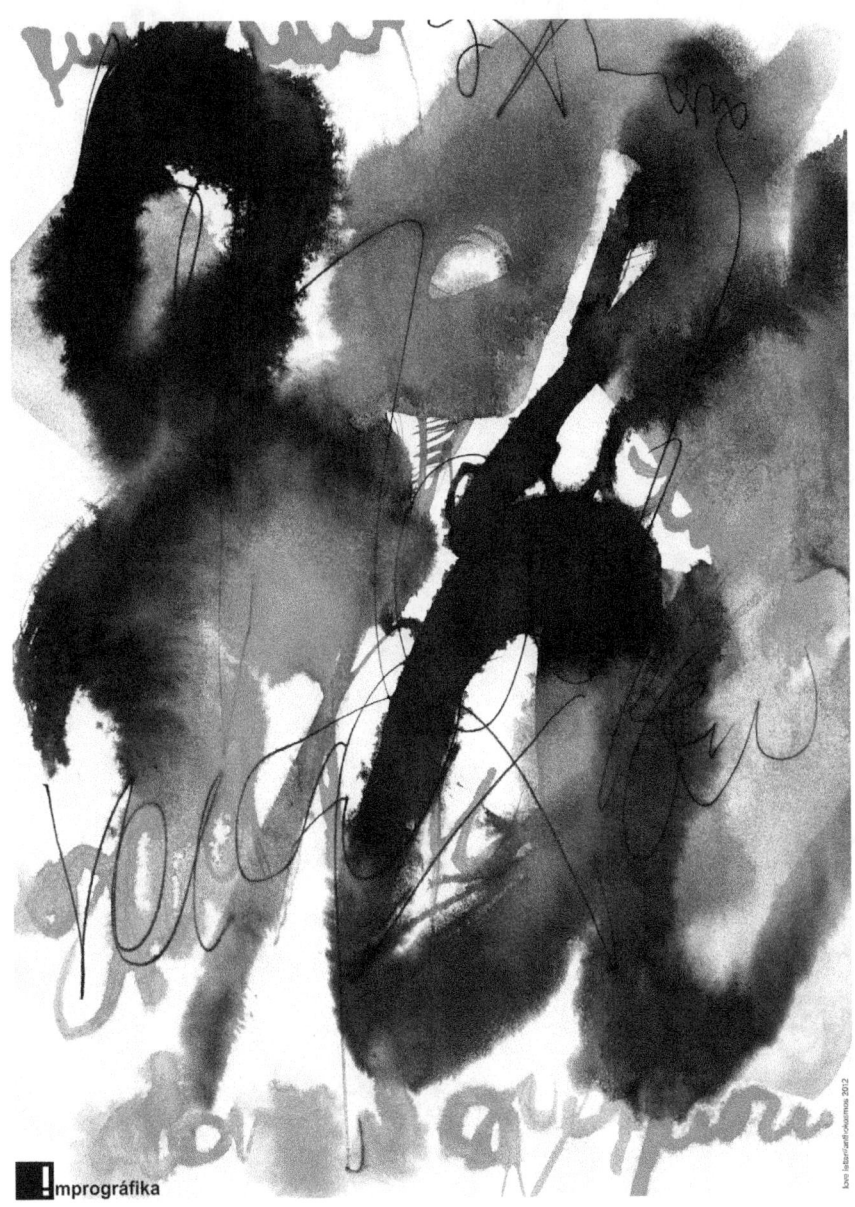

## Beyond the Image

Memories reside
Beyond the image
Beyond the traces.

Images of memories
Become then, memories of traces.
Memories of bodies
that trace over a surface.

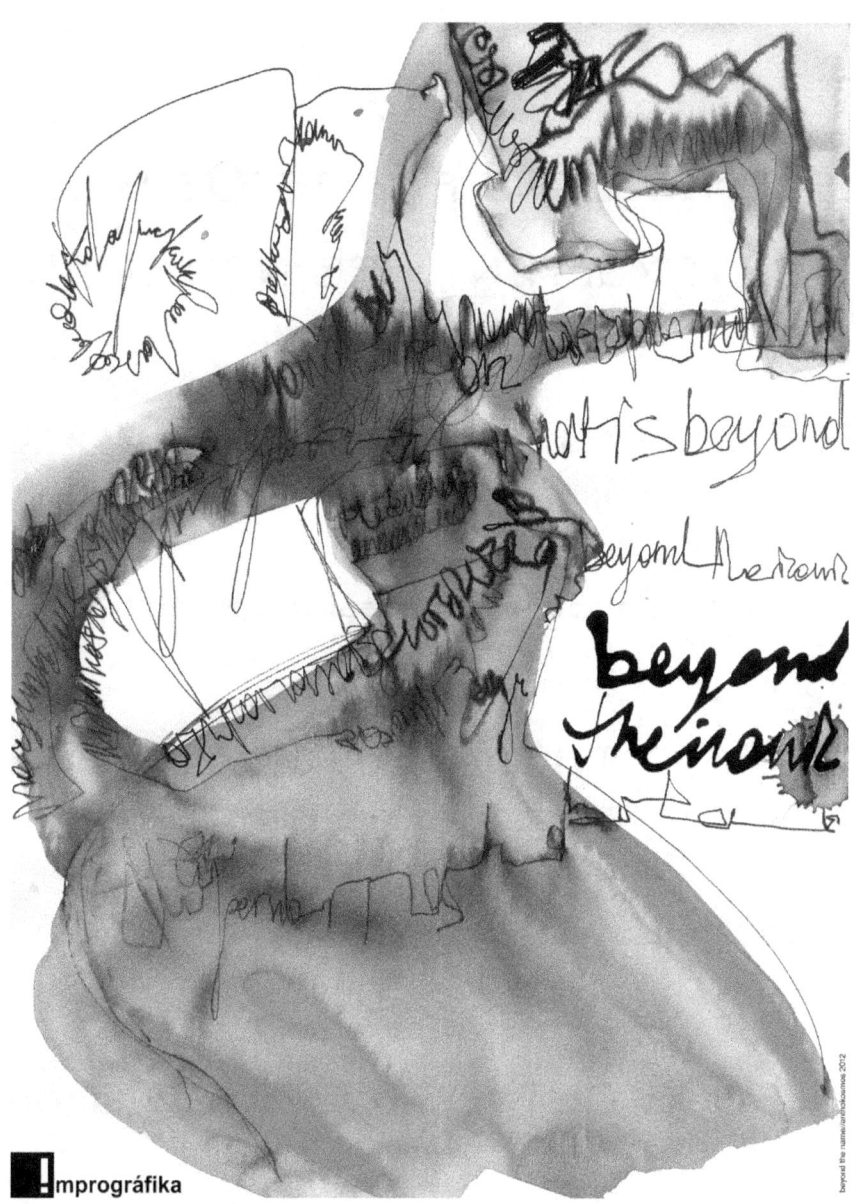

SUBMISSIONS FOR ISSUE 5 OF POETRY&PAINT ARE NOW OPEN!

SEND UP TO 4 PAGES OF WORK TO

poetryandpaintsubmissions@gmail.com

THEME: FUTURE

DEADLINE: 31ST AUGUST 2015

DUE OUT: OCTOBER 2015

# POETS & PAINTERS

## DEAN ATTA

Dean Atta is a writer and performance poet. He has been commissioned to write poems for Keats House Museum, National Portrait Gallery, Tate Britain and Tate Modern. His debut poetry collection *I Am Nobody's Nigger* was published in 2013 by The Westbourne Press.

www..deanatta.co.uk

## CHARLES BANE JR

Charles Bane, Jr. is the American author of "The Chapbook "( Curbside Splendor, 2011) "Love Poems "( Kelsay Books, 2014) and "Three Seasons: Letters With Donald Hall" ( Collection of Houghton Library, Harvard University). He is a current nominee as Poet Laureate of Florida.

www.charlesbanejr.com

## JACKIE BIGGS

After a successful career as a journalist and editor, Jackie Biggs is now a freelance writer and poet. She has had work published

on websites and in magazines and anthologies, including the *The Lampeter Review*, *Innovate* arts magazine and the *Haiku Journal*. She has been Honno's Poet of the Month. A member of the PENfro Poets, she writes mainly to perform poetry at Live Literature events all over west Wales, where she lives. Much of her inspiration for poetry comes from local landscapes and the work of many local talented artists. She is due to publish a collection of work in autumn 2015.

www.jackie-news.blogspot.co.uk

## BEN CONNORS

Ben Connors is a graduate of Fine Art from Central Saint Martins Ben has worked in Sculpture, Performance Art and Film. It is not so much the format or the medium that has typified his work but the collaborative relationships often at the root of them. He has worked with Holly Darton (of Hunt and Darton), Gabriel Hardisty-Miller (PigPen), Gilles Peterson, as well as poets such as Dean Atta and Aja Monet, and arts organisations including Heart'N'Soul and Artsadmin. Whilst the nature of an illustrator is often a commercial one, Ben tends to work in a way that stems from his prior experiences, leading projects with a vibe, seeking out meaningful subjects and collaborators to align with his unique perspective. The organic journey his practice has taken is reflected in his style of

drawing, sometimes messy, sometimes wonky, sometimes awkward. It is a style developed from the school of gig posters and photocopied comic zines.

www.benconnors.blogspot.co.uk

## MATTHEW DICKERSON

Matthew Dickerson is an illustrator, graphic designer and concept artist. He currently lives in Norwich, working as a freelance artist. He has worked with companies such as Lard Ventures and Prana Custom Cycles. Most recently, he also designed the Kid Glove logo.

www.matthewdickerson.co.uk

## ELOISE GOVIER

Eloise Govier is a young British contemporary artist with a distinctive personal style. She currently resides in Bath, but makes frequent trips home to rural west Wales where she has a studio. Govier's paintings are bold, bright, textured and show optimism and daring *joie de vivre* in the thick, brilliantly-coloured strokes. She also creates immersive art experiences and participatory artworks using brightly coloured neon bricks. The artist has been exhibited internationally, including galleries in Japan, Amsterdam, Barcelona, Berlin, and London. She has also

received acclaim outside of the traditional boundaries of art; her art has been showcased at the London Morgan showroom, the AT-Bristol Science Center, and a Modernist Housing Estate in former East Berlin. She has been featured or interviewed by numerous magazines and newspapers, including the Aesthetica Magazine and the BBC.

www.eloisegoviergallery.com

## JAN SEE KING

Jan See King currently resides in South Pasadena, California. Publications include: Bravo, small library publications, Timeless Voices, and Lummox.

## ANTHOKOSMOS

Anthokosmos (commonly known as Anthi Kosma) studied Architecture at DUTH (Greece). She holds a PhD and DEA from ETSA of Madrid, UPM (Spain) with a scholarship from IKY and Triantafyllidis foundation.

www.imprografika.wordpress.com

## CARMINA MASOLIVER

Carmina Masoliver is a writer, poet and performer and part of the *Burn After Reading* community, and *Kid Glove* collective. Last year saw the publication of her first

pamphlet by *Nasty Little Press*, and she performed at various festivals including Latitude, Camp Bestival, Bestival, Secret Garden Party and In the Woods. She also facilitates workshops, which she has done independently, as well as alongside Ross Sutherland, Niall O'Sullivan and Michael Rosen. She recently won the Poetry Rivals 16-25 competition and a short film of her winning poem 'Paradise' has been captured by filmmaker Guy Larsen. In addition to writing her own poetry, she edits an anthology called *Poetry&Paint* and runs an event called *She Grrrowls* in London

www.carminamasoliver.com

## LOUISE SAUNDERS

Louise Saunders has been drawing since she could hold a crayon. Having recently graduated from Film Production at the AUCBournemouth, she has moved to London to seek her fortune. Ever keen to expand her portfolio and become a better artist, she is eagerly drumming up work as a storyboard artist and concept illustrator on various film projects. She has also done some illustration work for children's books and online comics, as well as completing private commissions as part of collaborative projects or as one off pieces, digital and traditional.

www.louisesaunders.artworkfolio.com

# ETHAN TAYLOR

Ethan Taylor is an Actor/Poet currently studying for his BA (Honours) in Acting in Guildford, UK. He has been/is due to be published in both online and hardcopy literary magazines including ExFic, Message In A Bottle, Snakeskin, Lighten Up Online, Peeking Cat and the Poetry Shed. He is currently a series writer for the website Channillo.com.

# KEIR YANSEN

A poet from London whose creativity is expressed through film, writing and performances, his short films have been aired across RichMix cinema, Jawdance and several short film festivals. He is currently working on his debut poetry book.

www.keiryansen.com

## Carmina is also the mind behind London's She Grrrowls